www.ingramcontent.com/pod-product-compliance
Lightning Source LLC
Chambersburg PA
CBHW082016230526
45466CB00022B/2379